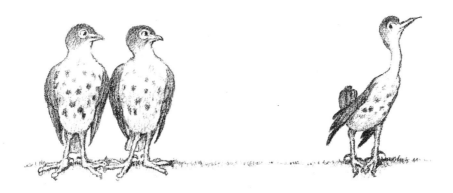

Willie Was Different

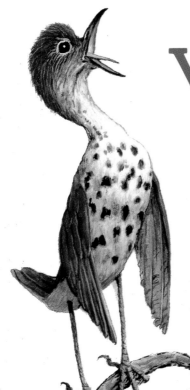

Willie Was Different

A Children's Story by
Norman Rockwell

Dragonfly Books™
Alfred A. Knopf ▲ New York

DRAGONFLY BOOKS™ PUBLISHED BY ALFRED A. KNOPF, INC.
Copyright © 1994 by The Norman Rockwell Family Trust

http://www.randomhouse.com/

Library of Congress Cataloging-in-Publication Data
Rockwell, Norman, 1894-1978.
Willie was different / written and illustrated by Norman Rockwell.
p. cm.
Summary: Realizing that he is different from other wood thrushes, Willie sets out on his
own and becomes famous when he creates his own songs to accompany a flautist who is
his devoted friend.
[1. Wood thrush—Fiction. 2. Individuality—Fiction. 3. Fame—Fiction.] I. Title.
PZ7.R59487Wi 1994
[Fic]—dc20 94-8785

ISBN 0-679-88262-6 (pbk.)

First Dragonfly Books™ edition: May 1997

Printed in Singapore
10 9 8 7 6 5 4 3 2

Foreword

Willie Was Different is a story that celebrates the discovery of genius and the satisfactions of true friendship. It also demonstrates that Norman Rockwell's love of storytelling could be expressed in writing as well as in painting.

Although *Willie Was Different* stands on its own as a beautifully crafted picture book, it has an interesting background, too. Rockwell's many surviving friends all agree that *Willie Was Different* was an autobiographical sketch. Rockwell drew Willie as a spindly, pigeon-toed character with unruly red hair, just as he sometimes portrayed himself in amusing, self-deprecatory sketches. *My Adventures as an Illustrator,* Rockwell's own life story, gives a fuller flavor of the autobiographical nature of *Willie Was Different.* Whether Miss Polly was modeled on Molly Punderson Rockwell, his third wife, and the father and mother thrush on his own parents are questions his friends still debate with interest.

This version of *Willie Was Different* both is and is not the story's first publication. Rockwell wrote the story and offered it to *McCall's* magazine. He then did the color illustrations and *Willie Was Different* was published by *McCall's* in 1967. Rockwell seems to have intended his manuscript as an outline rather than as a finished text and he did not object to the many changes *McCall's* made to it. A year or so later, Molly Rockwell rewrote the story extensively and Rockwell did the black-and-white illustrations for the expanded text. That version was published as a book for adult and advanced-adolescent readers by Funk & Wagnalls in 1969.

This edition returns to Rockwell's original conception and as nearly as possible to his original manuscript, which, it can fairly be said, has never been published before. Though perhaps more like a working sketch than a finished work, Rockwell's original text has a clarity of expression, a mastery of narration, and an eye for telling detail reminiscent of his painting style. In this version, *Willie Was Different* is once again clearly a children's story, albeit one with great appeal to adults as well.

There are a number of true-to-life touches in the illustrations of the book. All of the figures in the "top-hat" illustration on page 22 were drawn from real ornithological personalities of the time. Also, Rockwell included himself in a number of the illustrations. There is a young Norman Rockwell on pages 18 and 31, and an older Rockwell, disguised by a balding head, also on page 18. He modeled for several other figures as well, but gave them different faces. Molly Rockwell posed for several of the Miss Polly pictures, but Miss Polly's face was not drawn from hers.

Sad to say, *Willie Was Different* is not a true story. Although Rockwell wrote it as if it were a narration of true events, there is no record of a thrush like Willie, either in the Stockbridge newspapers of the time or in the archives of the Ornithological Section of the Smithsonian Institution. Visitors there can hear wonderful bird songs, with perhaps none more beautiful than the song of the wood thrush, but there are no thrush cadenzas. The Willie Room, and Willie's fame, exists entirely in the pages of this book.

Willie was a wood thrush. In his thrush family he had a strict, proud father, a loving mother, and two rowdy older brothers named George and Albert.

Willie was different. He felt and looked different. He was gawky and pigeon-toed. Maybe way down deep inside himself he felt he was a genius.

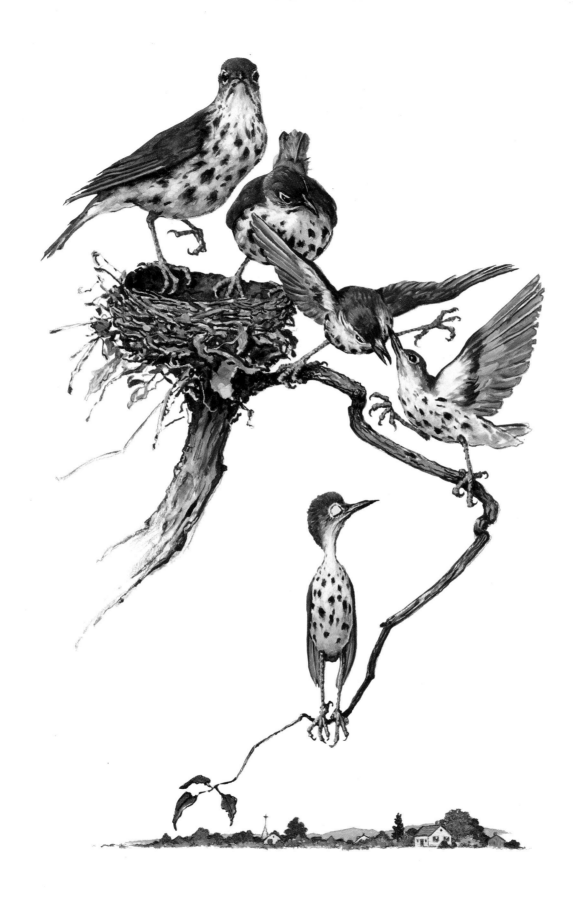

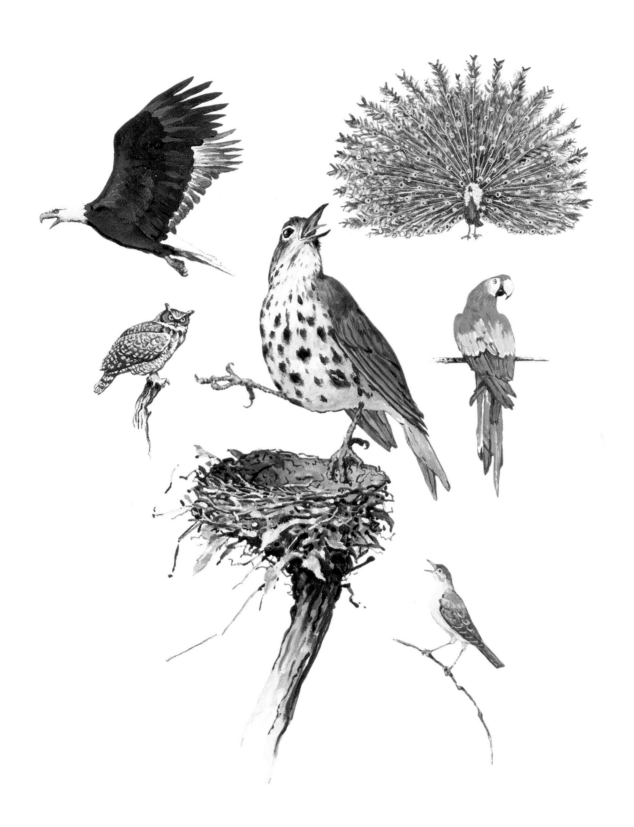

Willie's father was always preaching about the fine qualities of the wood thrush.
"A wood thrush," he would say, "is not mighty like an eagle. Or beautiful like a peacock. Or wise like an owl. Certainly wood thrushes do not try to talk like humans, as parrots do. Nor do they sing like nightingales. No! We have a simple song that has never changed through the ages!"

Willie's father would say, "It is only six notes long, but it is perfect, and it is glorious. Many famous human composers, such as Handel, Weber, and Gounod, have been inspired by our song."

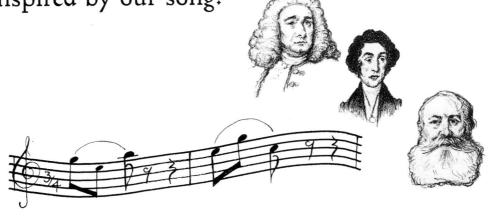

Willie was proud of being a wood thrush.
But he also wanted to be himself. He was
tired of his father's daily lectures and of
trying to be like every other wood thrush.
Finally, he just couldn't stand it anymore.
So he flew away to a neighboring wood and
made himself a new home, alone.

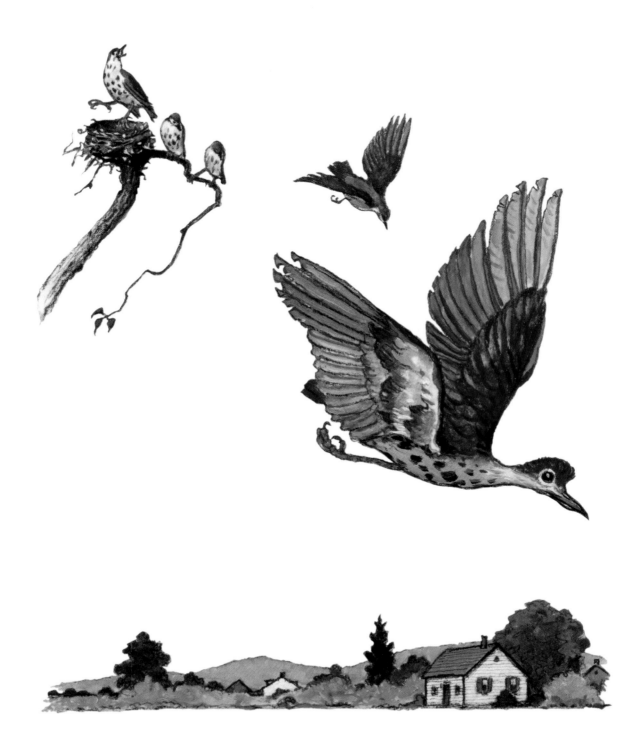

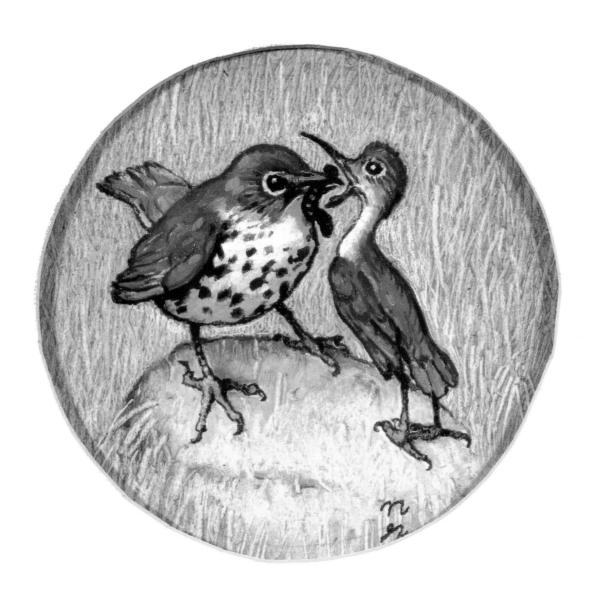

Willie's mother was concerned for him. She came to see him and made sure he was getting enough berries, spiders, worms, seeds, and wild fruits to eat, but she didn't try to convince him to return home. She was wise enough to let him live as he needed to live.

Willie was happy by himself in the woods. He flew about from birch to oak to pine tree and watched the sun rise and set, and wondered what his genius would be. Then one twilight, Willie heard the sweet notes of a flute. He flew closer to listen better.

Miss Polly, the town librarian, was playing her flute at an open window. She was playing a song by Handel which included the thrush's call.

Filled with joy to hear the thrush song from the flute, Willie began to sing along with it. At first he sang just the simple song of the thrush. Then he added cadenzas and trills inspired by his own moods. Willie realized his destiny! He must become a great, great singer!

Miss Polly had never been accompanied by a bird before, but she found Willie's music enchanting. She happily played duets with Willie until night fell and the moon rose.

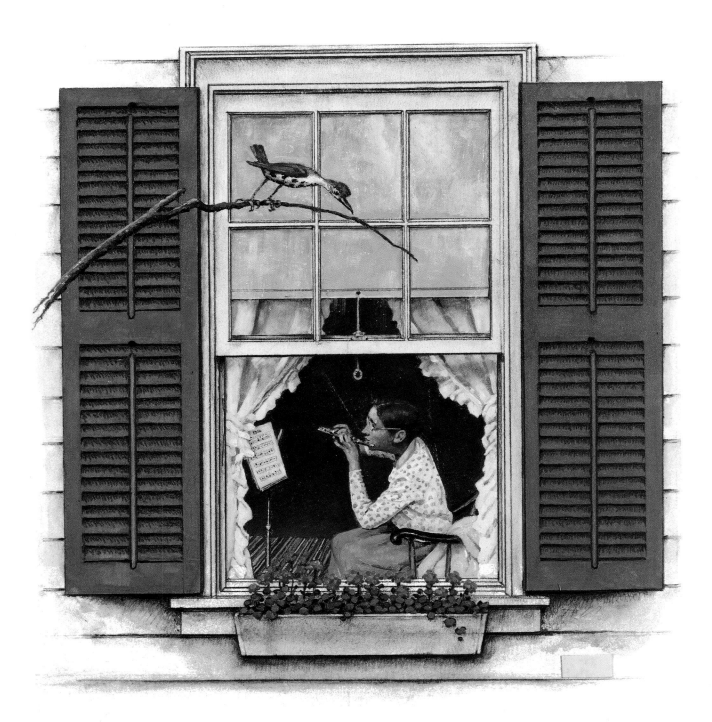

The next morning, Miss Polly walked through the woods until she heard Willie, practicing his songs in a tree. She took notes and that evening, at the regular meeting of the Bird Watcher's Society, reported the amazing news of Willie, the creative thrush.

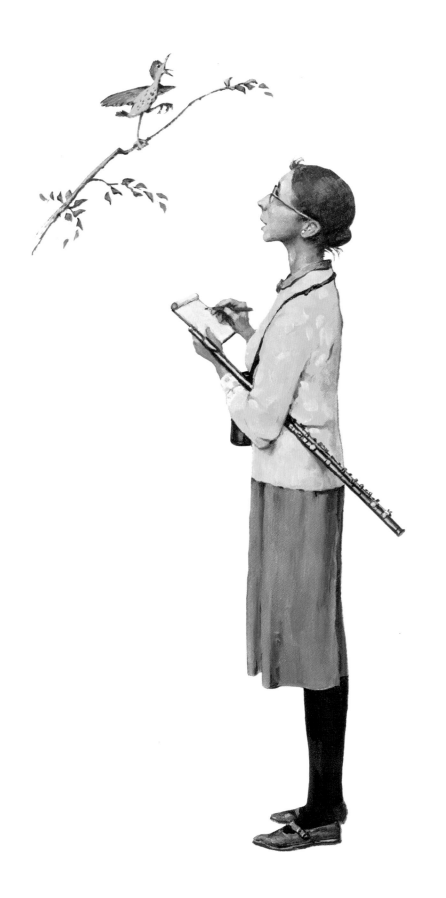

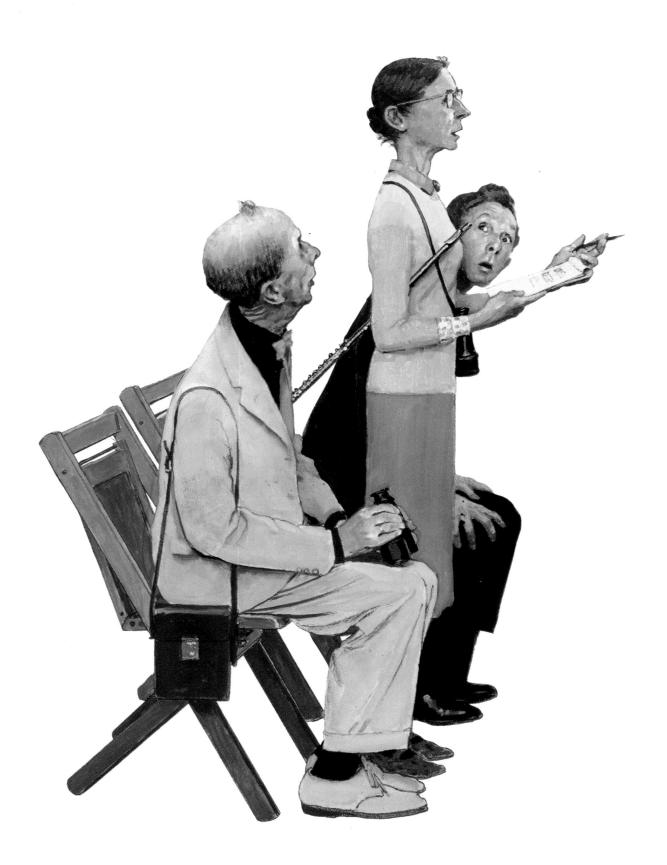

The bird watchers were flabbergasted. A thrush who composed his own music! No one had ever heard of such a thing! Could it possibly be true? They called up the experts at the National Ornithological Society in Washington, D.C.

The experts were flabbergasted, too, even if they wouldn't admit it.

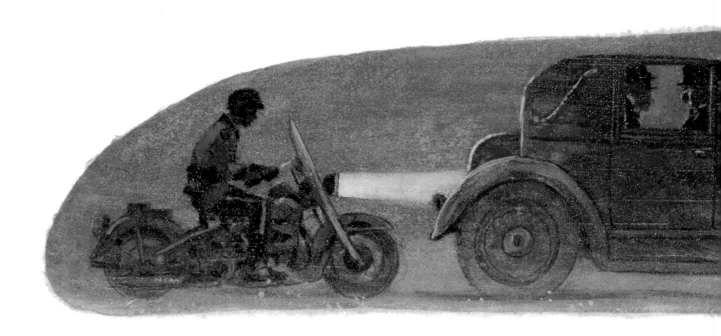

And that very night, a motorcade of ornithological officials in top hats arrived at Miss Polly's house to see and hear the miraculous Willie.

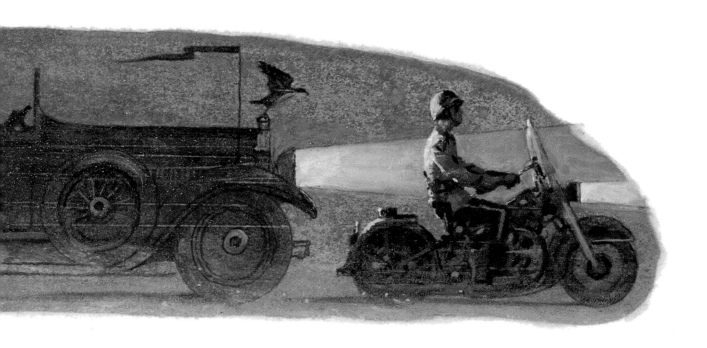

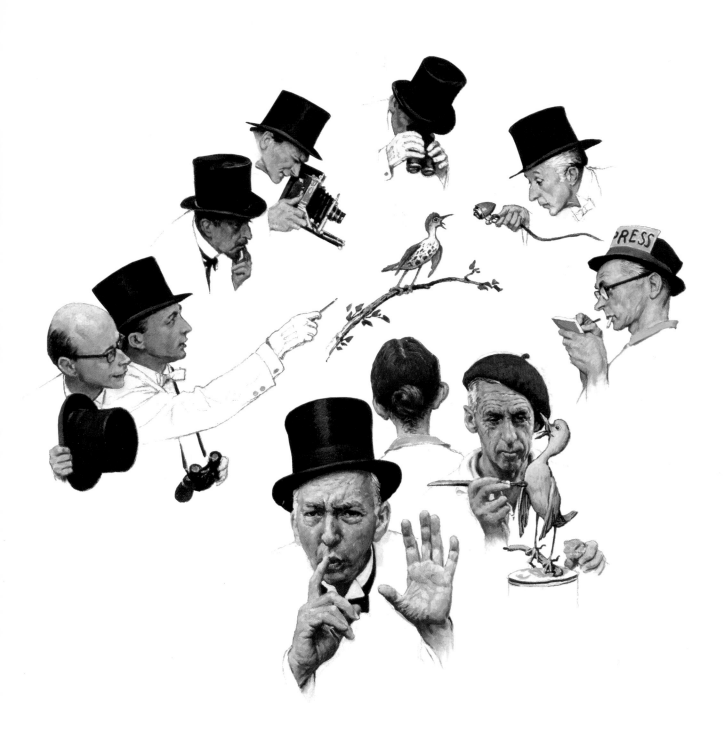

It was true! Willie, full of pride and genius,
sang his songs, though he didn't know what
to make of all the people peering at him,
snapping photographs, taking notes. Miss
Polly urged him to sing again and again.
Inspired, he sang more beautifully than ever
before.

His audience fell silent. Willie
was a genius! They knew it, and
Willie knew it, too.

But later, as Willie rested in the dim top of a pine tree and Miss Polly served tea, the ornithologists told Miss Polly that Willie was too important a bird to stay out in the wilds. He must come to Washington and live in the aviary there. All the world deserved a chance to see and hear this remarkable creature.

Miss Polly worried. The aviary would be so different from the woods behind her house. But she felt a duty to Willie's genius, so she took him on the train to Washington.

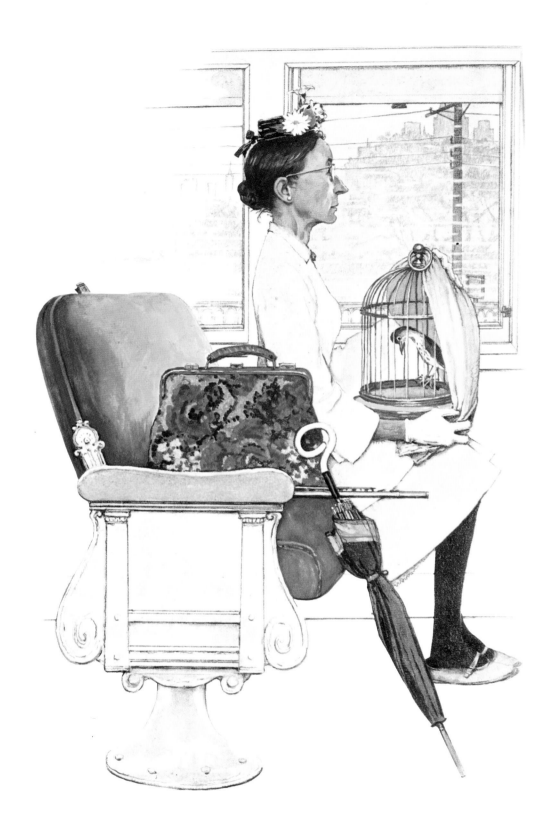

Miss Polly was right. Away from his quiet wood and surrounded now by hundreds of strange birds, Willie couldn't sleep or eat or fly. Worse still, he couldn't sing.

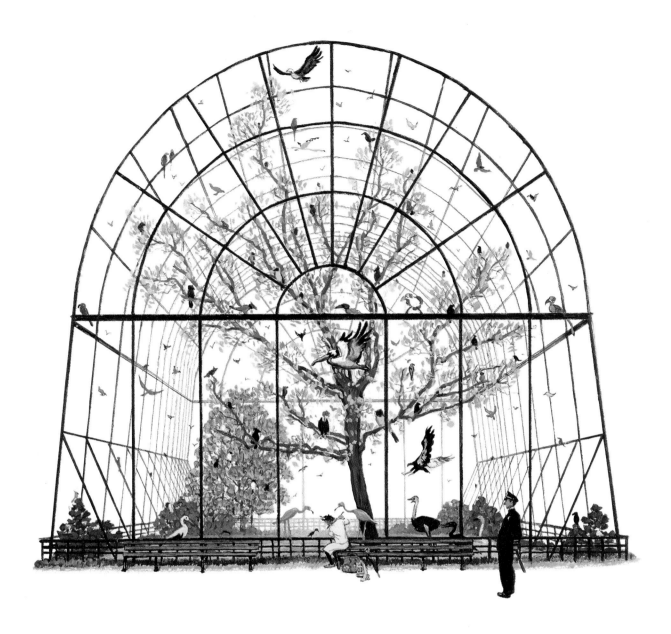

Not even the sound of Miss Polly's flute could cheer him or coax a note out of him. Willie was proud to be different, to be a genius, but he did not want to be a celebrity.

After a few days, Miss Polly put her foot
down. She took Willie back home and
returned him to his woods and meadows.

For quite a while, Willie kept to himself. But
then, hearing the sweet sounds of Miss
Polly's flute among the trees, he began to try
his songs again. Very softly, just for
themselves, Willie and Miss Polly, his true
old friend, brought to life the songs they had
created together.

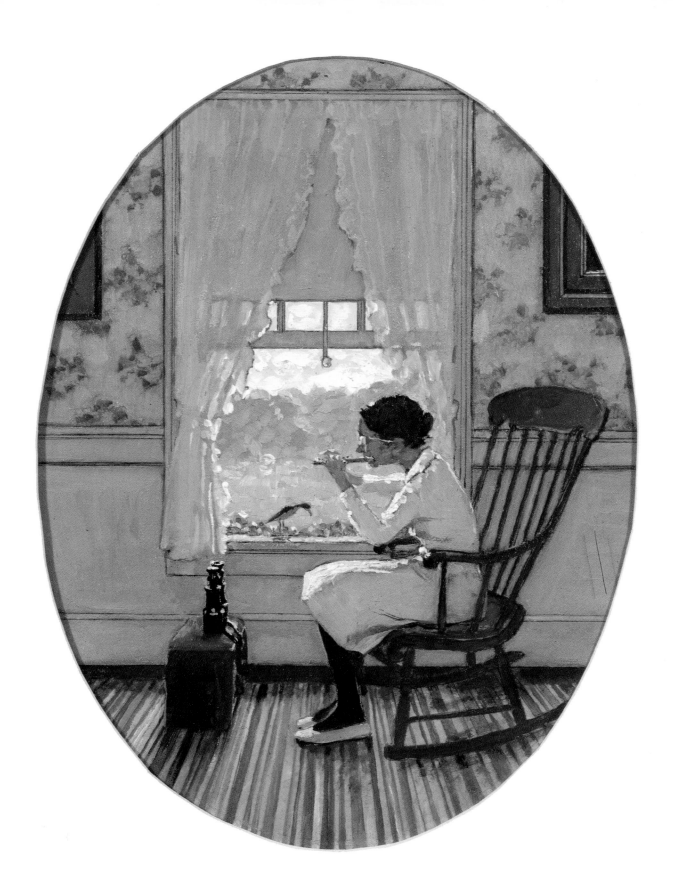

The rest of the world did not forget Willie.
The Ornithological Society built a shrine
called "Willie's Room" in their museum.
Even now, if you have the right spirit, you
can find it among all the hustle and bustle,
the honking horns and blaring radios of
Washington, and going in, you can hear for
yourself the miracle of Willie's genius, his
music.

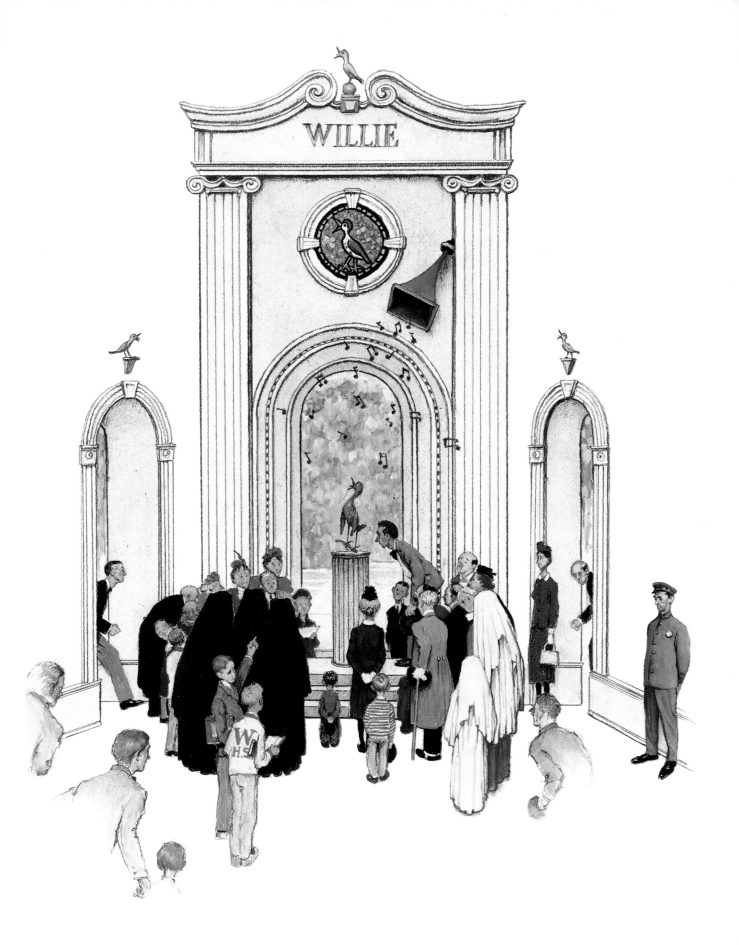

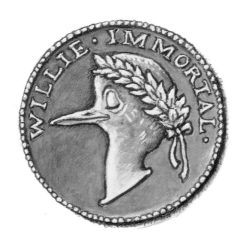

For that, as we know, was what made
Willie different.